Junior Science

color

Terry Jennings

Illustrations by David Anstey

Gloucester Press
New York · London · Toronto · Sydney

About this book

You can learn many different things about colors in this book. There are many experiments and activities for you to try. You will find out what primary colors are, why a rainbow is many different colors, how animals use color and much more.

First published in the United States in 1989 by Gloucester Press 387 Park Avenue South New York, NY 10016

ISBN 0 531 17129 9

Library of Congress Catalog Card Number: 88-83098

© BLA Publishing Limited 1988

This book was designed and produced by BLA Publishing Limited, TR House, Christopher Road, East Grinstead, Sussex, England. A member of the Ling Kee Group London Hong Kong Taipei Singapore New York

Printed in Spain by Heraclio Fournier, S.A.

There are lots of different colored things in the picture and there are three hoops. One hoop is labelled "red," one "blue," and the other "yellow." The ball goes in the red hoop. The plastic brick goes in the yellow hoop. Where would you put the other things?

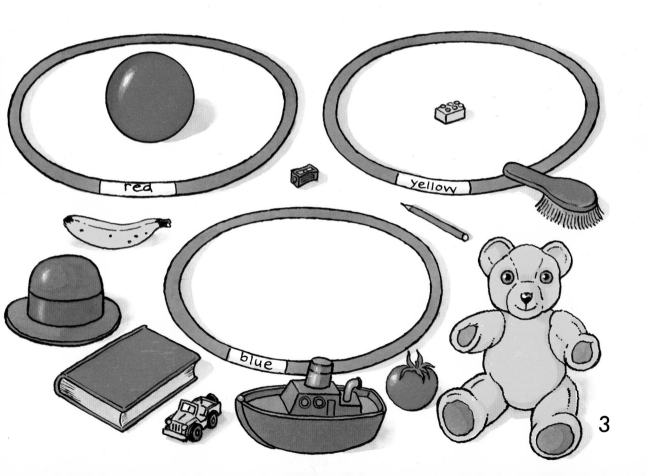

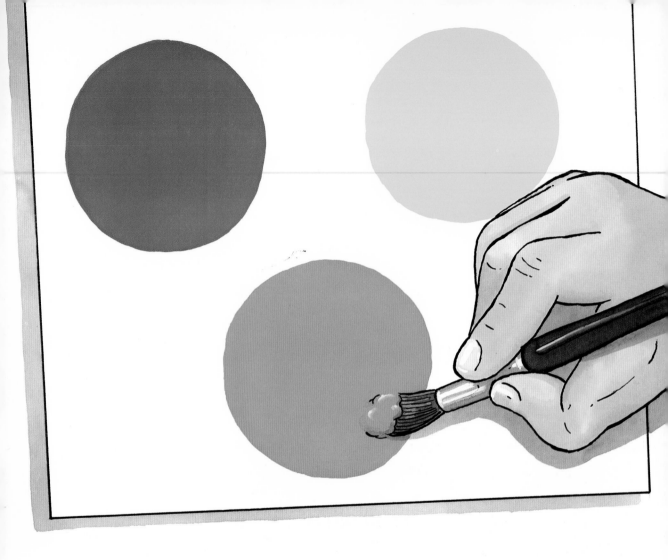

Red, yellow and blue are very important colors.
They are called primary colors. You can make lots
of other colors by mixing these primary colors.

4

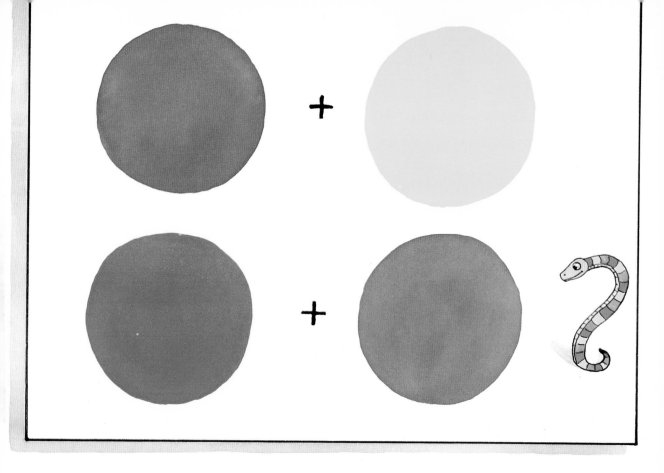

Paint a big red spot on a piece of paper. Then paint a big yellow spot. Mix both red and yellow together. The two colors will make an orange spot. Blue and yellow paint mixed together make green. And red and blue paint make purple.

5

Make a spinning top like this. First cut out a circle of thin cardboard and make a hole in the center of it. Color the cardboard red and yellow. Then push a very short stub of pencil through the hole.

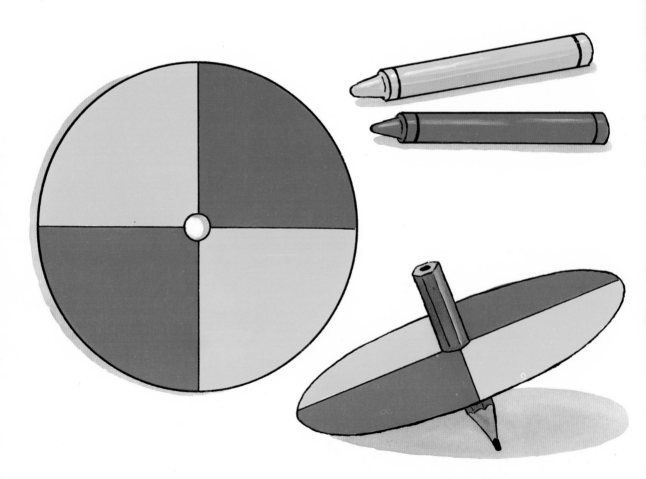

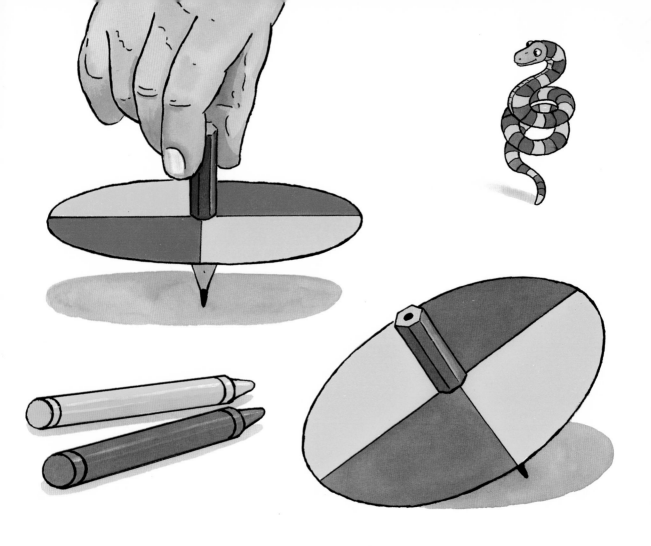

Now spin the top very fast. You will see that the spinning top becomes orange. A blue and yellow top would become green.

Cut out some round pieces of blotting paper. Draw a big orange spot in the middle of one of them with a magic marker. Put the paper on top of a jar and drip water onto the orange spot using a drinking straw.

The spot will grow as the water soaks through the paper. But it will not stay orange. It will spread out into red and yellow rings. A green spot will separate into blue and yellow, and a purple spot would separate into red and blue.

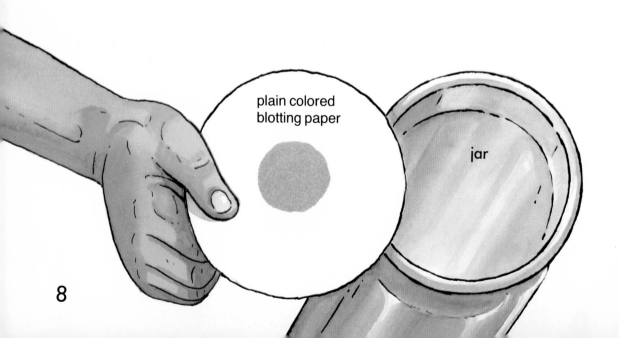

plain colored
blotting paper

jar

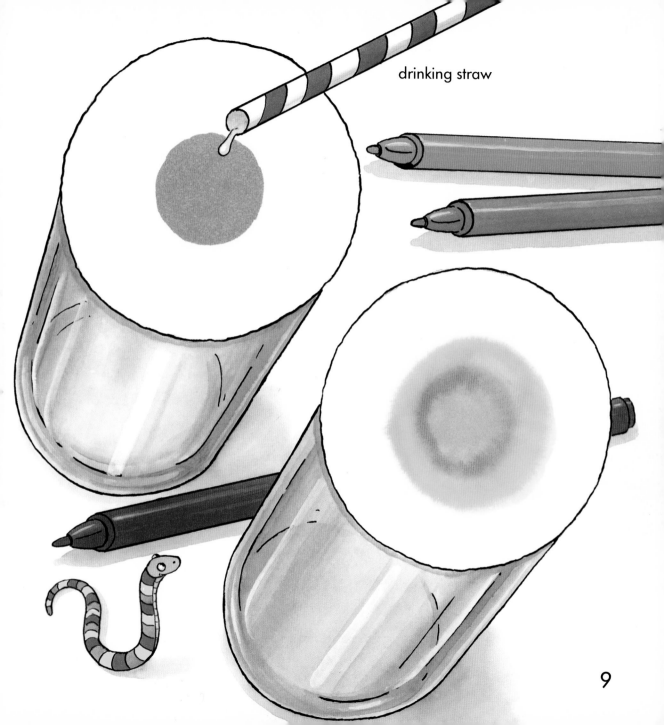

drinking straw

9

Draw a pair of glasses like this onto a piece of stiff cardboard.

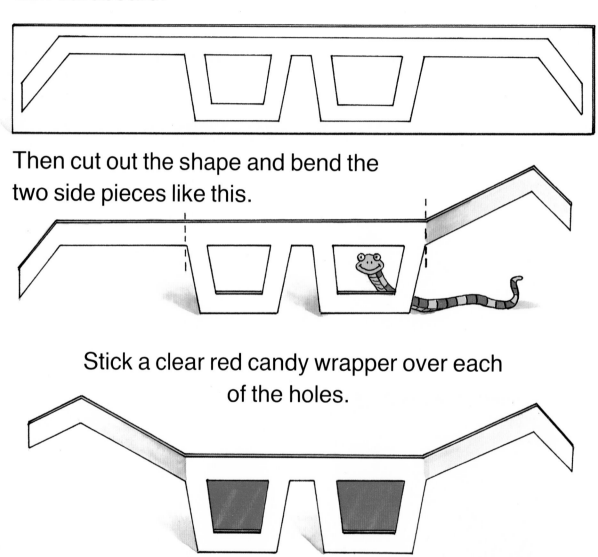

Then cut out the shape and bend the two side pieces like this.

Stick a clear red candy wrapper over each of the holes.

Look at something white with your red glasses. It will seem red. Now look at other things and make a table like this. Everything you look at will be reddish. If you use a blue candy wrapper everything will seem blue.

Red glasses		
Things looked at	Colors seen	Color it really is
Ball	Red	White

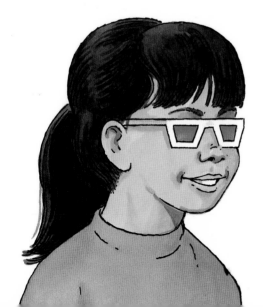

11

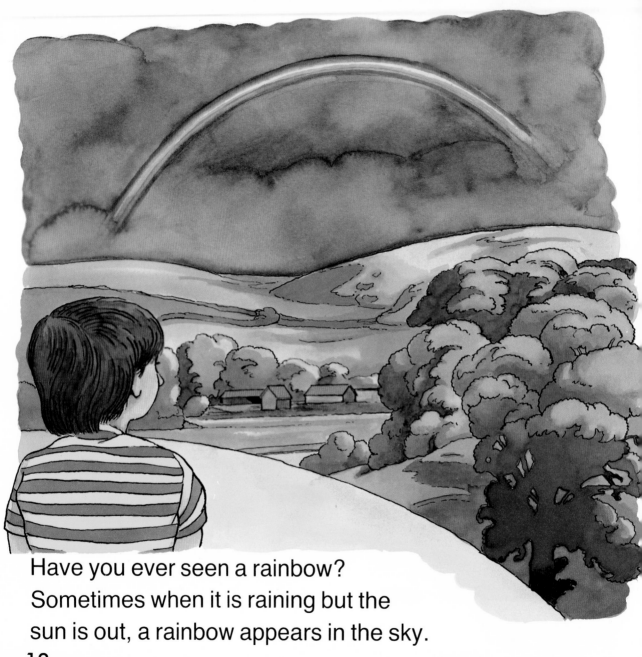

Have you ever seen a rainbow?
Sometimes when it is raining but the
sun is out, a rainbow appears in the sky.

12

You can make a small rainbow indoors. Take a shallow dish and put it near the window. Put a small mirror in the dish. Tilt the mirror so that the light coming from the window shines onto the ceiling. Fix the mirror in place with modeling clay. Now fill the dish with water. When the water has settled, a small rainbow will form on the ceiling. But if you stir the water with a pencil, the rainbow will disappear.

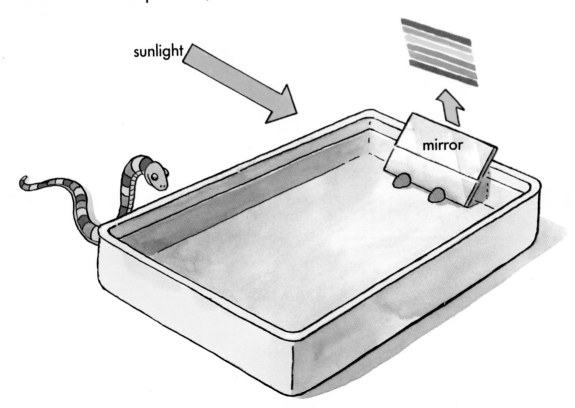

sunlight

mirror

Sunlight looks white. But it is really a mixture of colors. Raindrops break the white light up into many different colors. This results in a rainbow.

Make a "whizzer" like this. Cut out a circle of cardboard and paint it with as many colors as you have. Make two small holes in the circle and tie a loop of string through the holes.

Now wind up the whizzer like this.

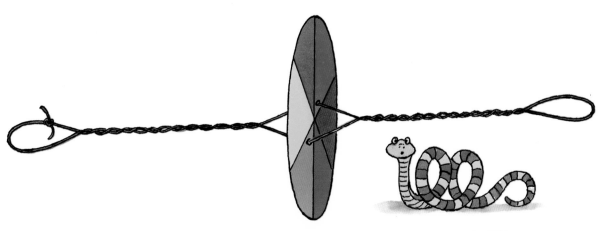

Pull the string so that the whizzer spins around. The whizzer will look white as it spins because the different colors appear to combine.

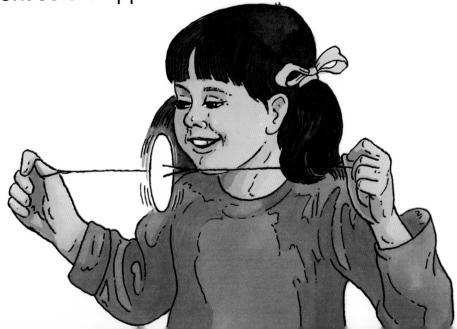

Many flowers are brightly colored. Bees and other insects can see them from far away. The insects go to the flowers to feed on nectar and collect pollen. They take the pollen to other flowers. Then these flowers can grow seeds.

Watch a bumble bee outside. It will go to lots of flowers. Write down the color of the flowers the bee goes to. Now make a table like this and see which colored flowers the bee visits most.

Colors of flowers	Visits made by bumble bee
White	3
Yellow	1
Red	9
Purple	5
Blue	2

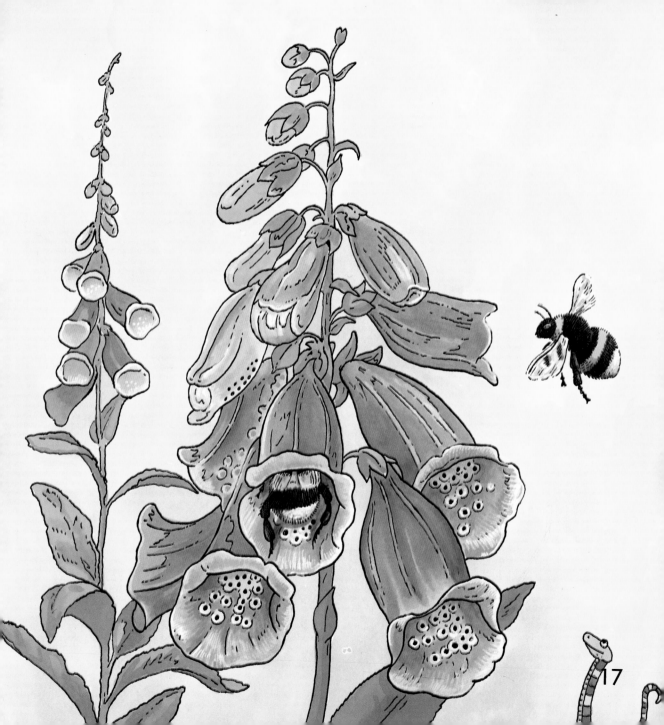

17

Many birds and butterflies are brightly colored. But some animals have dull colors. These dull colors match the animals' surroundings. This rabbit is a gray-brown color. When it sits still the rabbit is hard to see. It looks like a lump of soil.

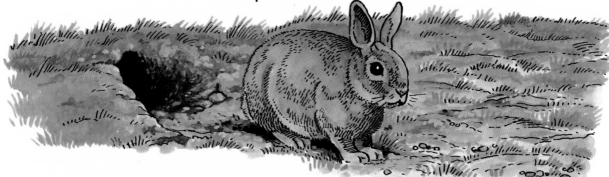

This duck is a dull brown color. When it sits on its nest the duck cannot easily be seen by its enemies.

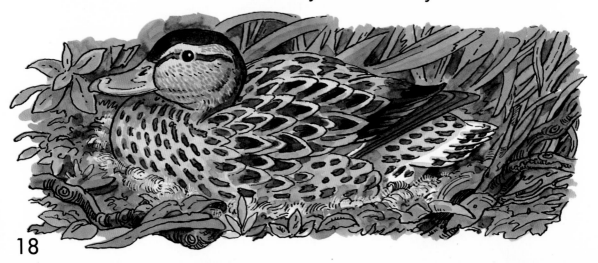

Some animals change color to match their surroundings.
In cold places, hares and stoats turn white in winter.
Then they match the snow.

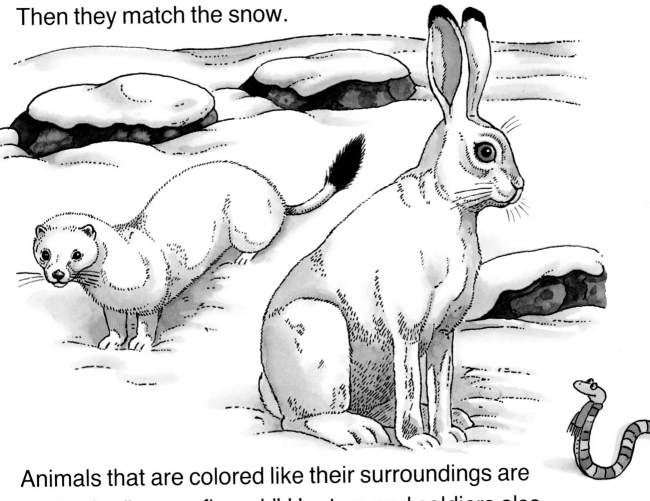

Animals that are colored like their surroundings are
said to be "camouflaged." Hunters and soldiers also
use camouflage.

19

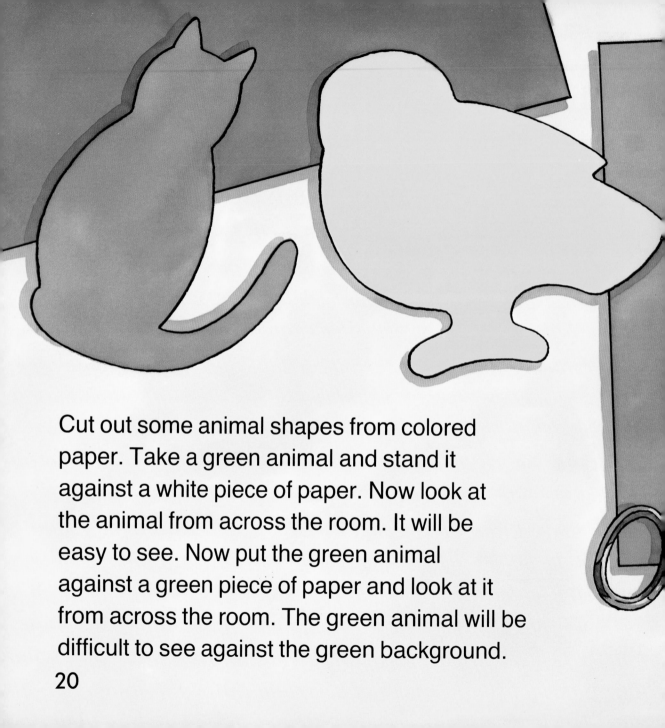

Cut out some animal shapes from colored
paper. Take a green animal and stand it
against a white piece of paper. Now look at
the animal from across the room. It will be
easy to see. Now put the green animal
against a green piece of paper and look at it
from across the room. The green animal will be
difficult to see against the green background.

Sometimes colors are used to tell us something. Traffic lights tell drivers to stop or go. Police cars, fire trucks and ambulances have colored flashing lights on top. In this seashore picture there is a red flag flying to tell us it is dangerous to swim in the sea.

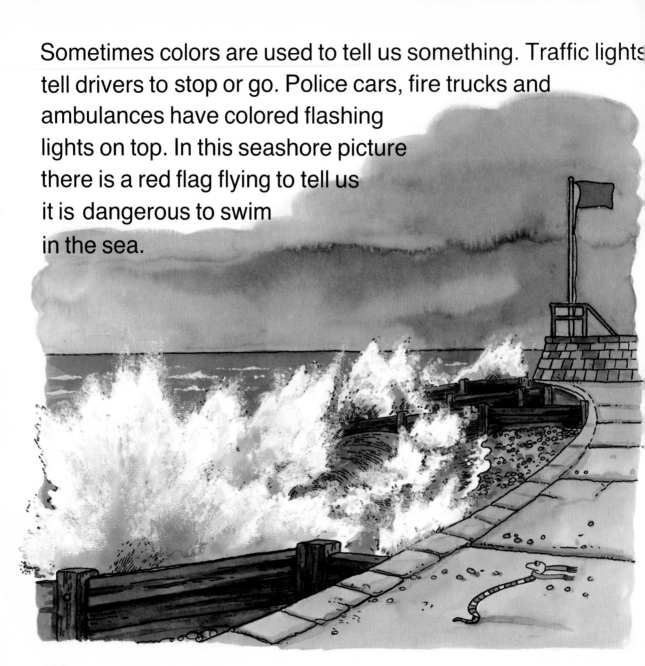

glossary

Here are the meanings of some words you may have used for the first time in this book.

camouflage: an animal is camouflaged when it is hard to see because its color matches its surroundings. Hunters and soldiers also use camouflage.

insect: a small, six legged animal with no backbone, such as a fly, bee or ant.

pollen: the yellow dust made by flowers.

primary colors: one of three colors which, when mixed, can produce any other color. The primary colors of paint are red, yellow and blue. The primary colors of light are red, blue and green.

rainbow: the curve of many colors seen in the sky when the sun shines through the rain.

23

index